THE
SENIOR
MOMENTS
DOODLE BOOK

THE
SENIOR
MOMENTS

DOODLE BOOK

ANDREW
PINDER

MICHAEL O'MARA BOOKS LIMITED

First published in Great Britain in 2010 by
Michael O'Mara Books Limited
9 Lion Yard
Tremadoc Road
London SW4 7NQ

A CIP catalogue record for this book is available from the British Library.

Papers used by Michael O'Mara Books Limited are natural, recyclable products
made from wood grown in sustainable forests. The manufacturing processes
conform to the environmental regulations of the country of origin.

ISBN: 978-1-84317-492-9

1 2 3 4 5 6 7 8 9 10

www.mombooks.com

Illustrations and cover illustration by Andrew Pinder

Designed by Design 23

Printed and bound in Finland by WS Bookwell, Juva

Decorate a special cake for a special birthday.

Meet the ancestors…

What really adventurous thing would you like to do?

Senior pastimes 1 – Model boats

Fill the pond.

Where is the barroom bore going?

Show them what you used to get in your Christmas stocking when you were young.

Draw your own bio-pic.

Who's made a mistake in their choice of beachwear?

What's in the bathroom cabinet?

Here's Beauty, now draw the Beast.

How many cats?

No, Mary hasn't gone senile, she just likes cats ...
... don't make eye contact.

What's going on on the bowling green?

What has she put out instead of the cats?

What food is there at the old-fashioned birthday party?

What's the actress saying to the bishop?

What is his chat-up line?

Draw them a dignified way to the bar.

What is in the

Design the Botox machine.

Draw Mr Higgins's outfit.

Mr Higgins, that's not the sort of costume we like at the 'Autumn Gold Rest Home' fancy dress night.

Sketch the boffin's greatest invention.

PATENT UN-LOSEABLE KEYS

Design a great place for a girls' night out.

Where are they going in the charabanc?

What has the feisty grandmother
done with the Big Bad Wolf?

Design a computer game for the more mature player.

This totally sucks!

Senior pastimes 2 – Gardening

Landscape this garden.

Think of a great labour-saving device.

What's happening in the bedroom farce?

Oh no! Quick, it's the vicar!

Design the hardest golf hole ever.

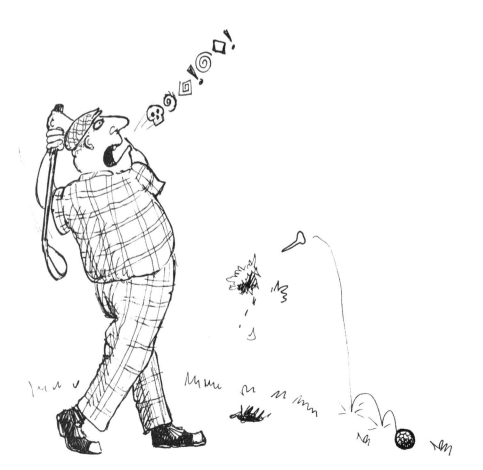

What HAS she done?

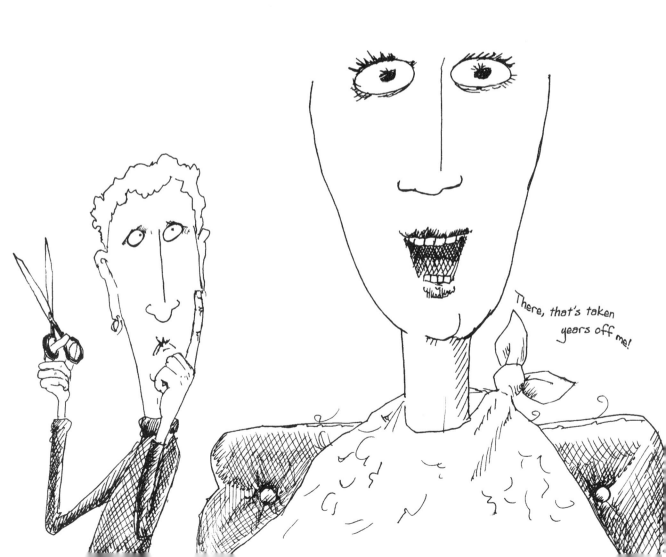

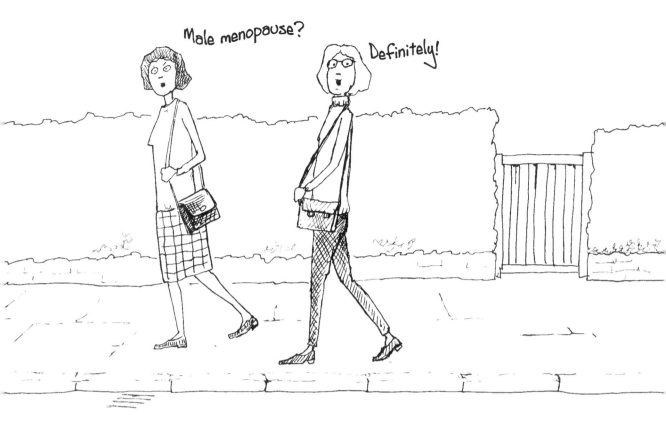

Draw the babe-magnet.

What's in her handbag?

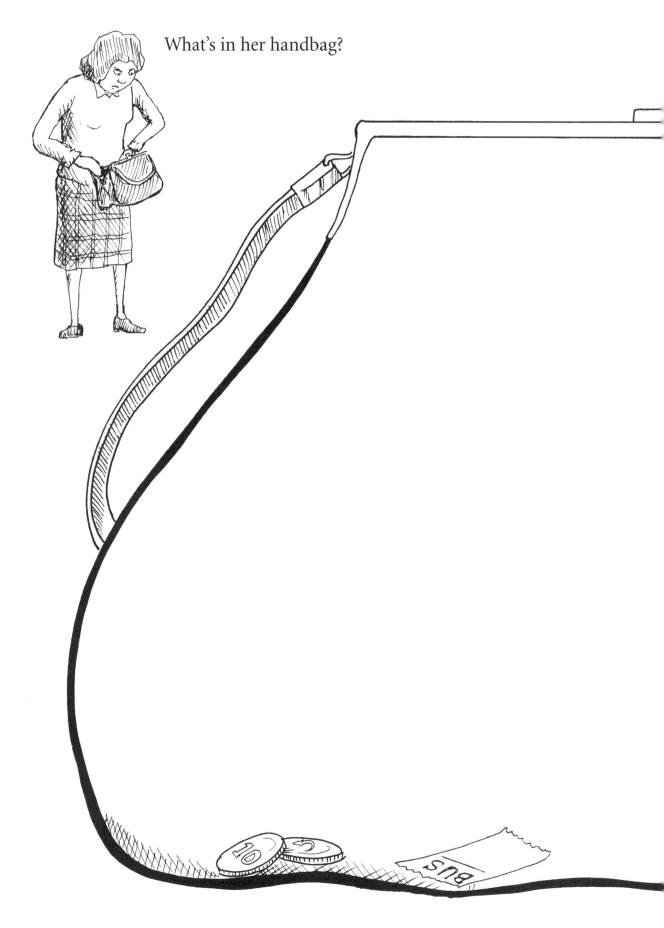

Draw the ageing hero.

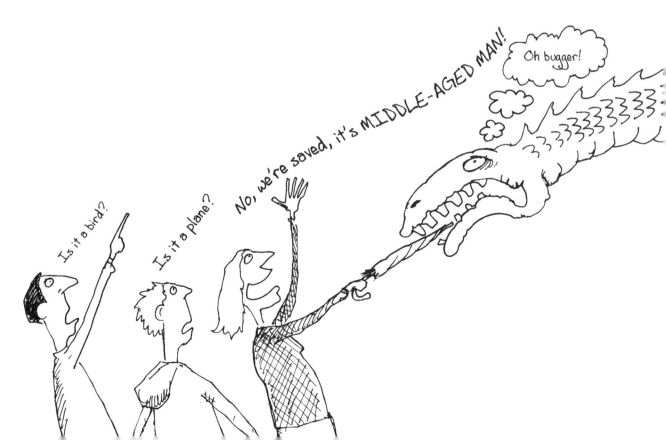

What's he wearing to the sixties-themed party?

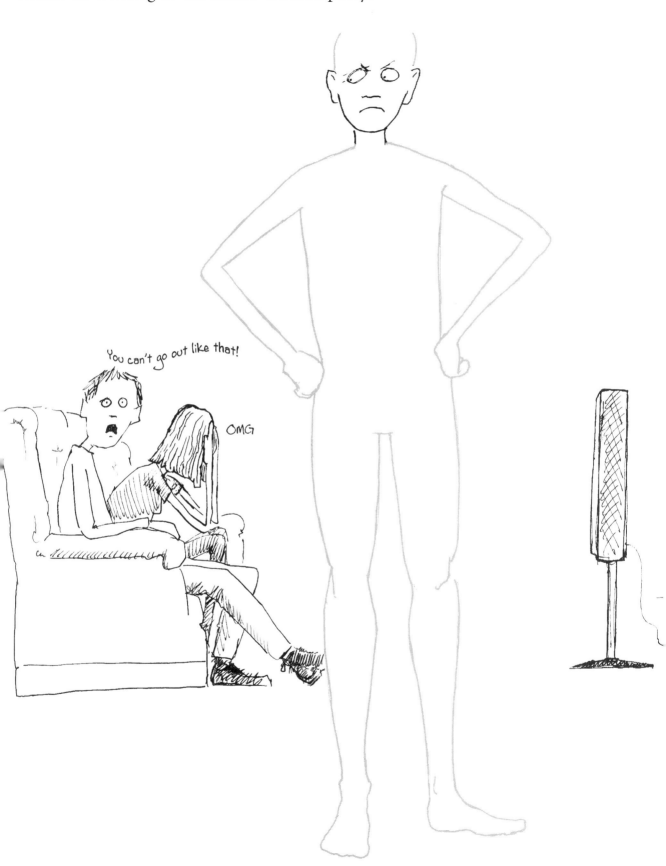

Confession time – draw your youthful fashion disasters.

Draw the Speedo King in mid-dive.

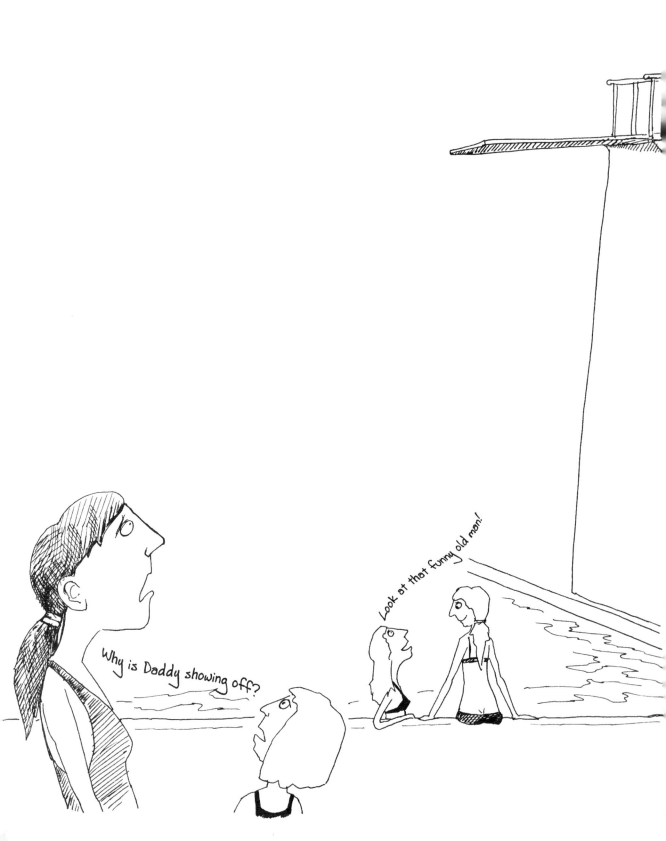

You lot have it soft these days, when I was a lad ...

Every kid's nightmare… Draw dad in action at the skate park.

What's on the table?

Doodle your dream holiday.

Design a great place for a lads' night out.

Senior pastimes 3 – Model trains

Finish the layout.

Finish the holiday snaps.

'The Quest for the Lost Glasses' – help him get to his prize.

What's tempting her?

Impress you neighbours – take up topiary.

Fill in the invitations and stick them on your mantelpiece.

Status Civitatis Vaticar

BUCKINGHAM PALACE.

Palais de l'Élysée

THE WHITE HOUSE
WASHINGTON

When I was your age I didn't hang around the cave all day painting mammoths, I ...

What has she lost from her shopping trolley?

Memory jog – doodle where you've left your:

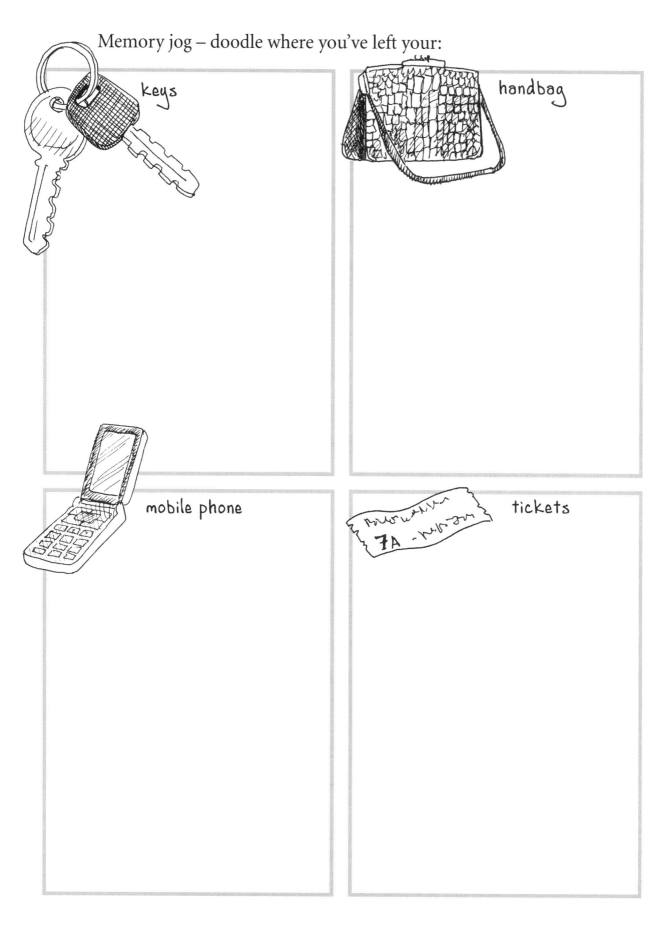

keys

handbag

mobile phone

tickets

7A

glasses

teeth

other half of
your sandwich

grandchildren

Give your neighbour a surprise – paint a mural.

Where have they beamed down?

What's this muck? When I was a girl we had proper television ...

Finish the saucy postcards.

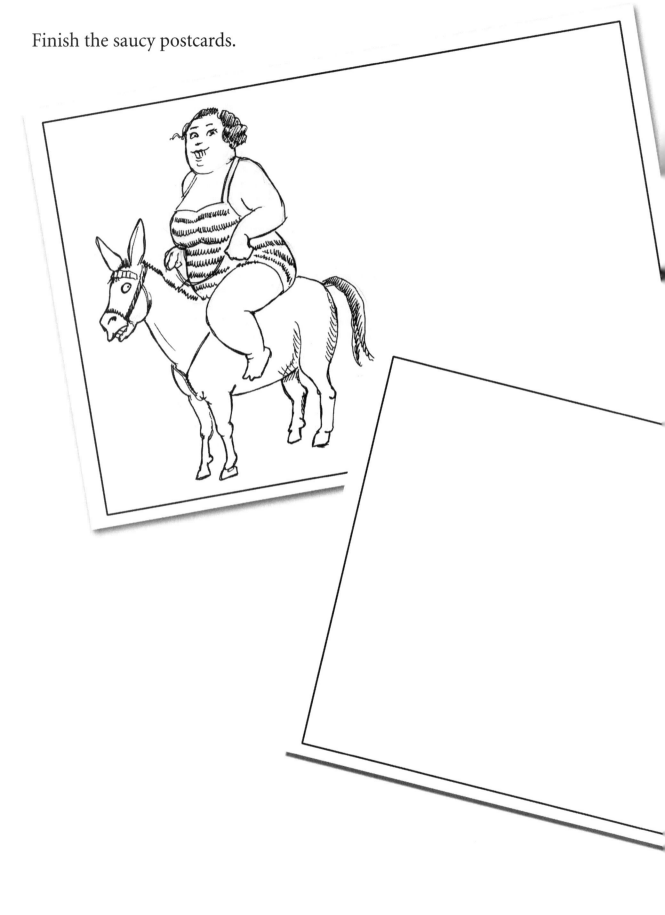

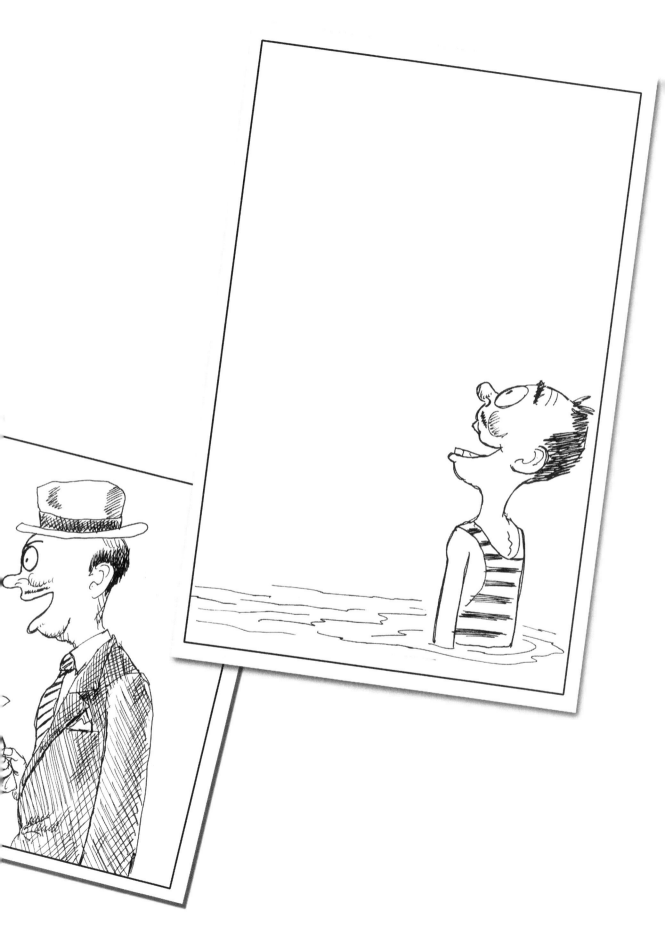

What has disrupted the greyhound race?

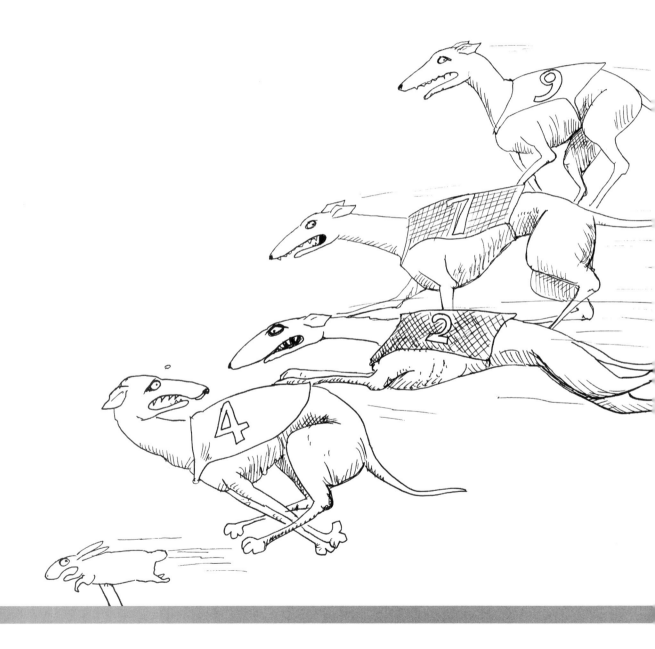

Senior pastimes 4 – Model making

Finish the matchstick building.

Cut a new hill figure.

What's happening in the old children's TV show?

What's scared the ramblers?

Don't leave me stranded here!

Fill in their placards.

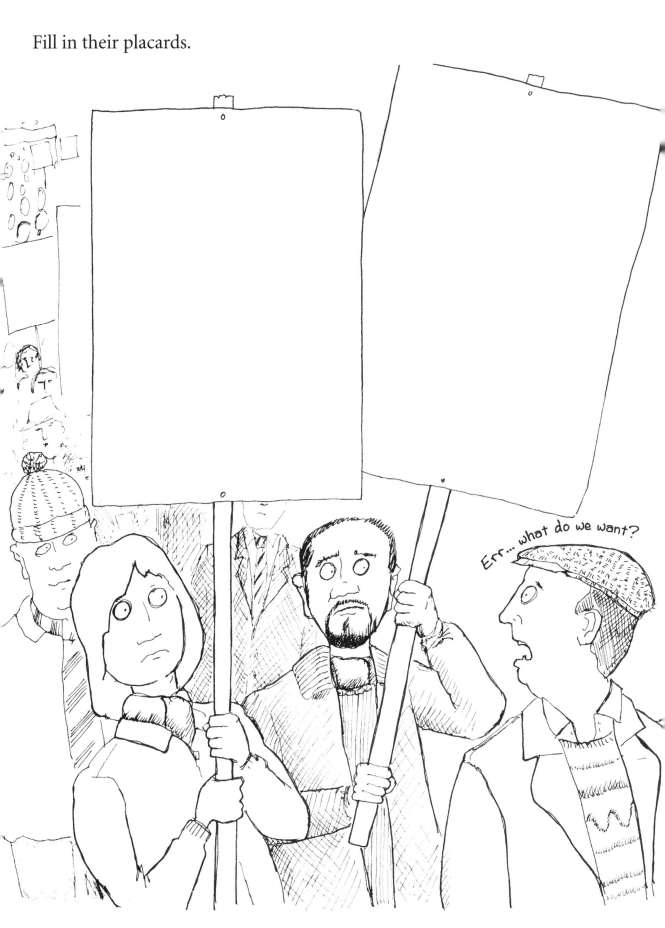

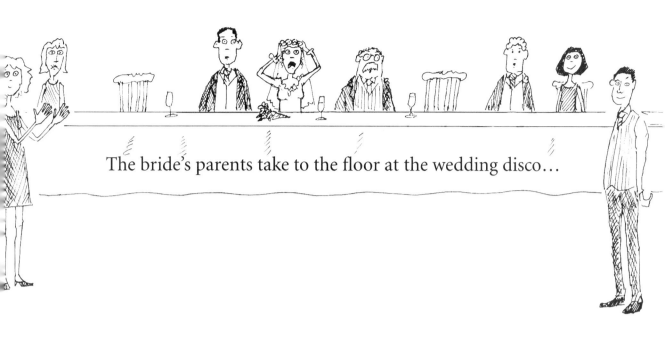

The bride's parents take to the floor at the wedding disco…

As they grow older, people and their pets begin to resemble each other…

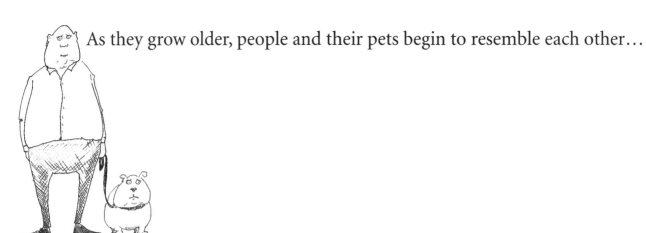

Draw my owner.

Draw my pet.

Draw my owner.

Hair receding? Get a toupee.

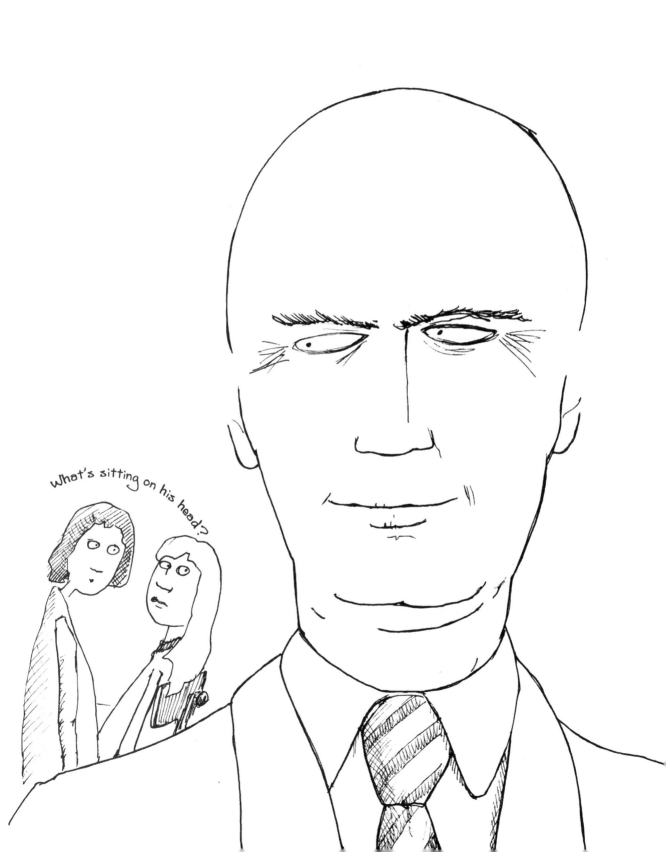

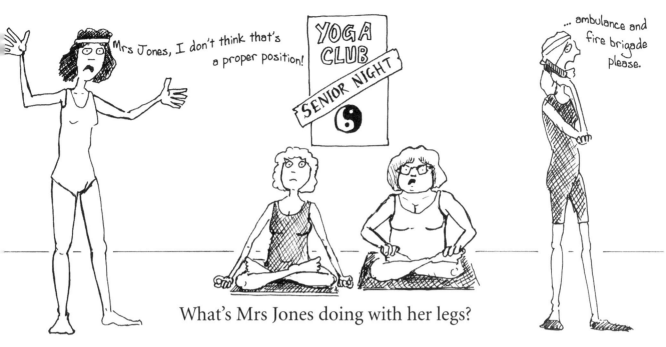

What's Mrs Jones doing with her legs?

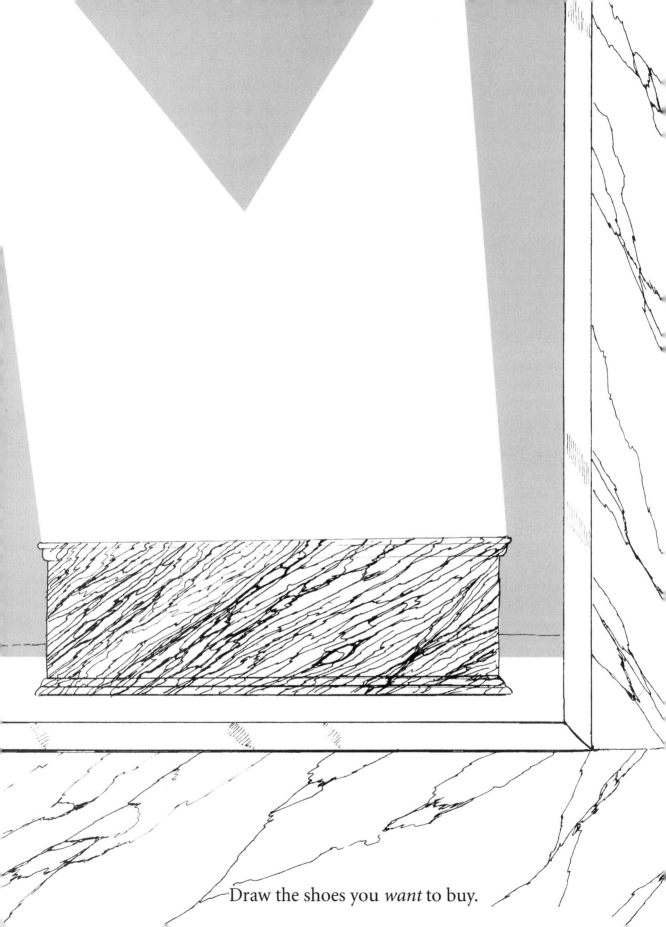

Draw the shoes you *want* to buy.

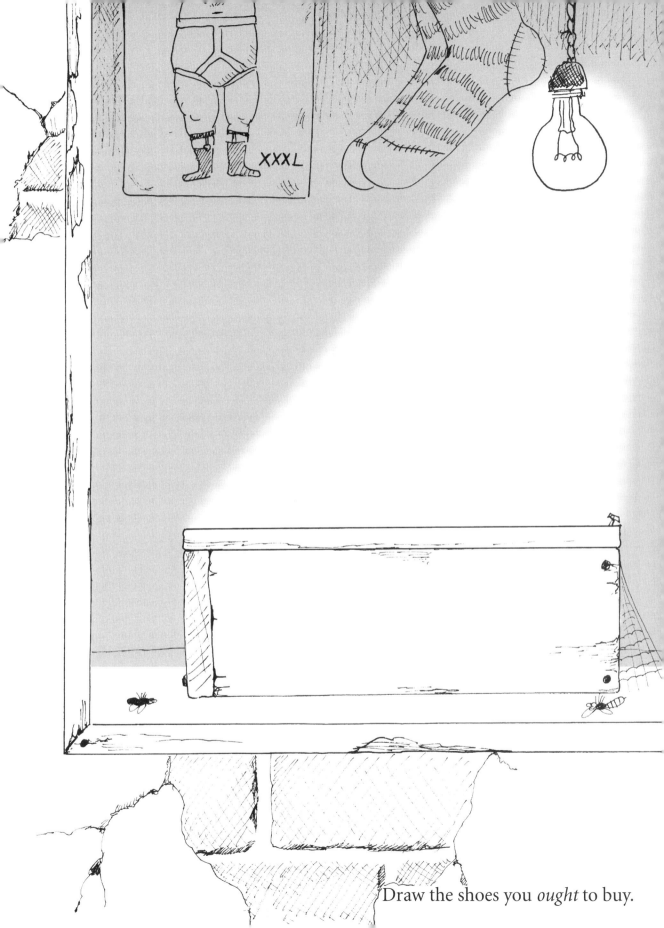

Draw the shoes you *ought* to buy.

The older a man is, the higher he wears his trousers…

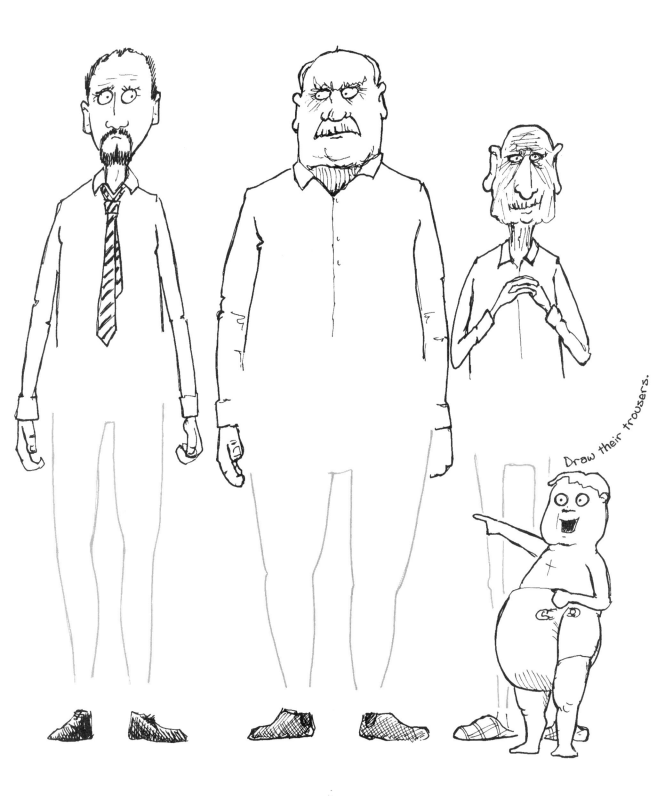

Draw their trousers.

A pleasure of maturity: eyebrow-, ear- and nose-hair topiary…

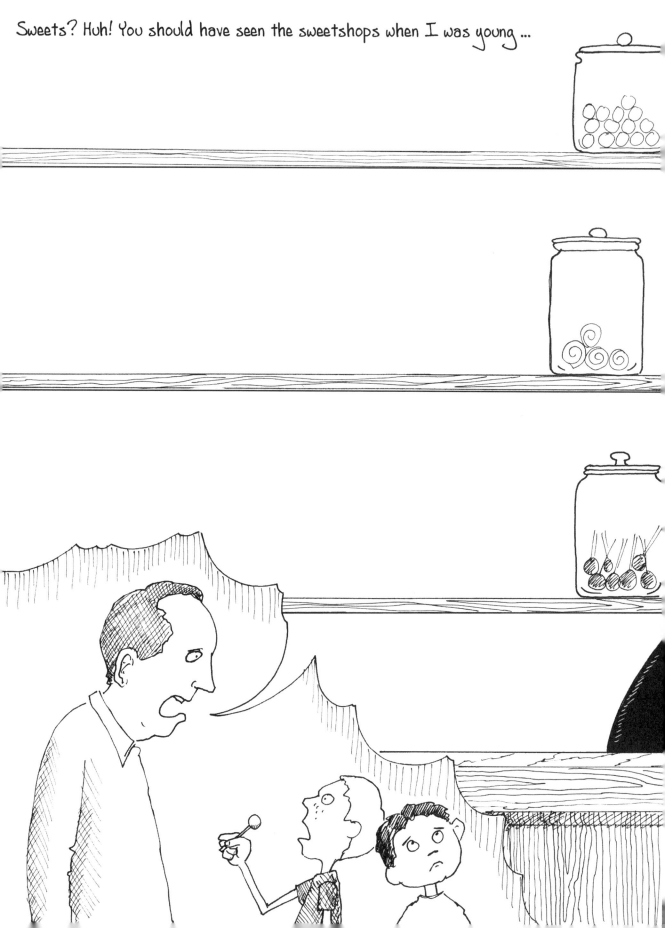

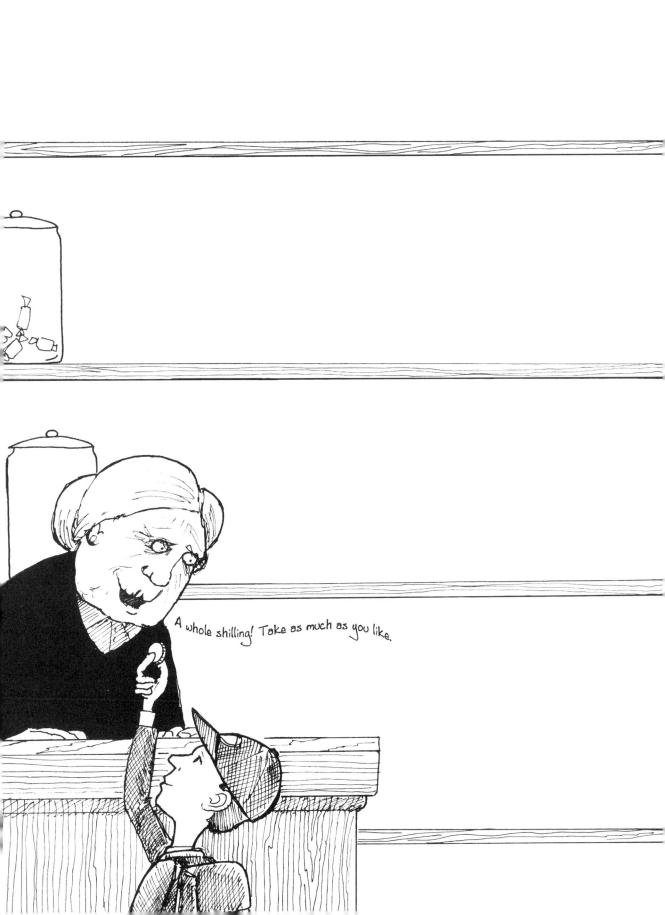

Suck it all in . . .

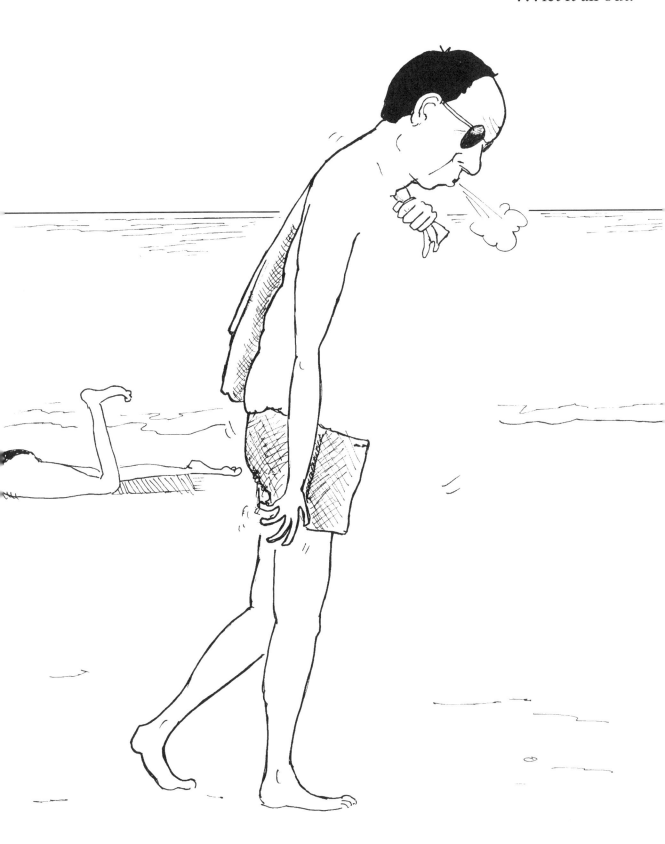

. . . let it all out.

Furnish the Count's pied-à-terre.

Mature titled gentleman GSOH, own teeth, seeks lady for fun and companionship. P.O box 23

Oh no! We're under attack!

Finish the old wedding photograph.

1 ... 2 ... 3 no, it's not working.

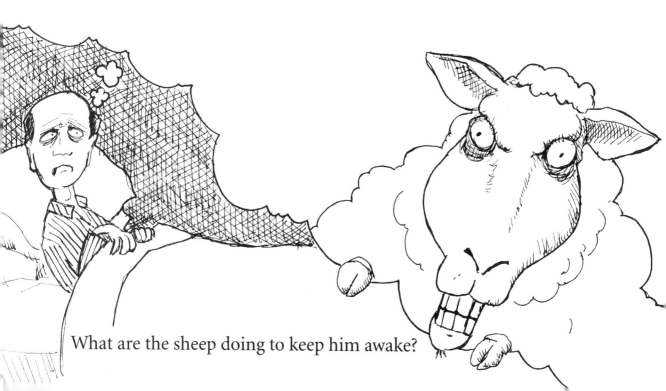

What are the sheep doing to keep him awake?

What's on the full-body scanner?

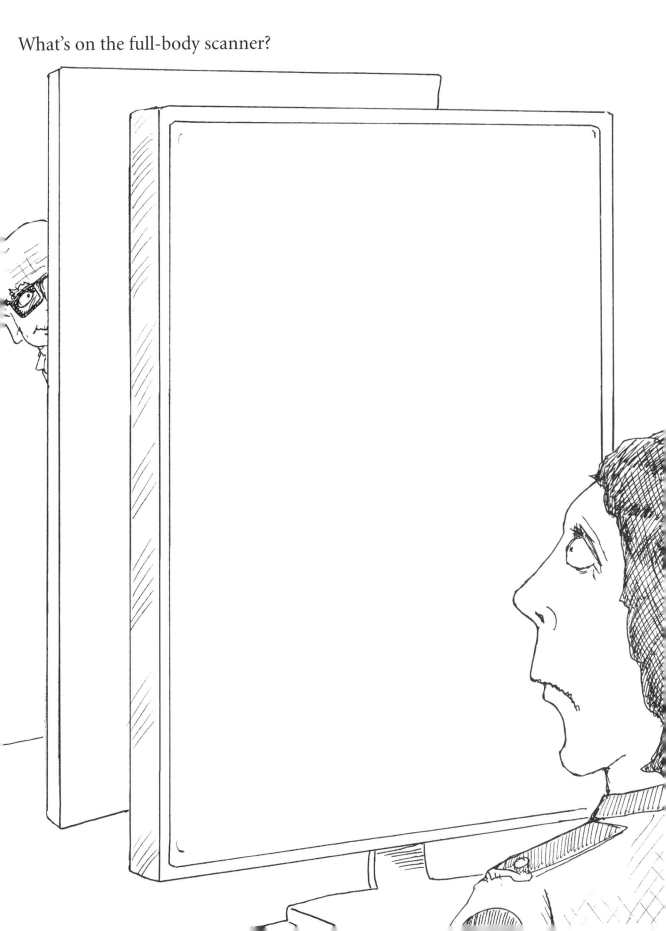

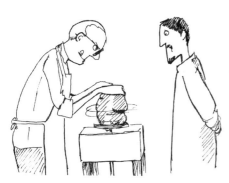

Senior pastimes 5 – Pottery classes

What has he made her?

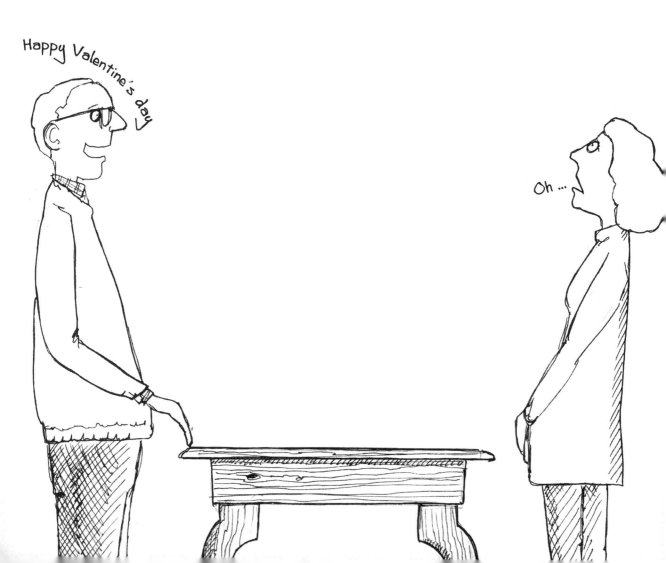

Who's onstage at the old-time music hall?

What has he brought back from university?

Customize his new car.

What's been sucked up?

Finish the old school photograph.

Holidays were more fun in the olden days. What's happening on the beach?

Design a logo for a big sporting event ...

... and design a hideous mascot to add to my collection.

What toys did you have in your toy cupboard?

Well, it was a good party last night… Draw the aftermath.

What's in the skip?

... quick, clear their rooms.

What's gone wrong with the trick?

Years ago we had proper acts on television ...
Draw the ventriloquist's dummy.

What bargains in the souk?

Tarzan is feeling his age today. Help him get to his tree house.

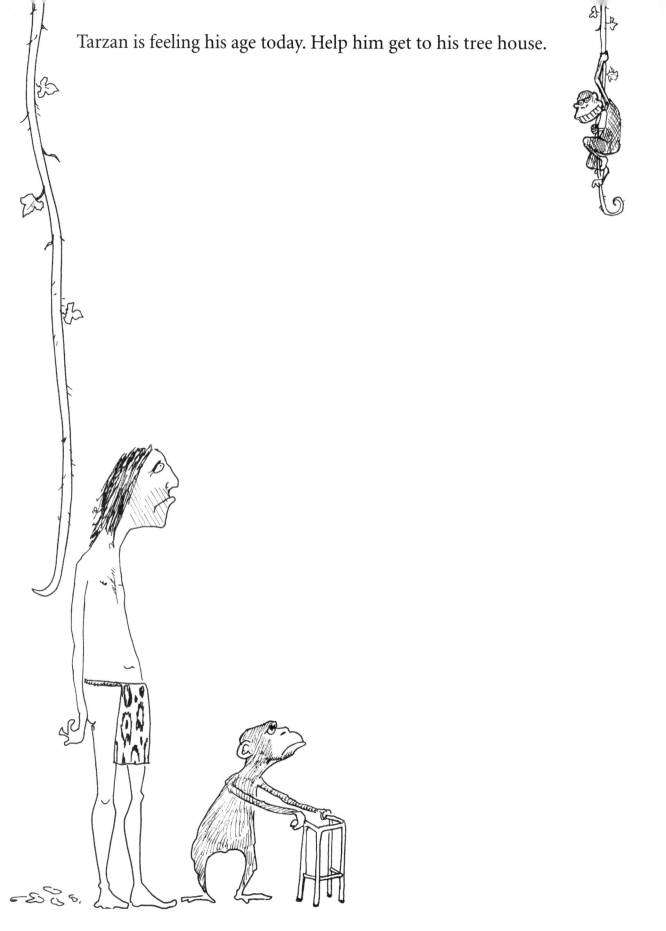

Draw your hero.

Just look what they're wearing! Do you remember when we were that age ...

Fill the stall with masks.

Oh no! Where have his teeth gone?

Maturity versus youth – with age comes cunning. How is he going to win?

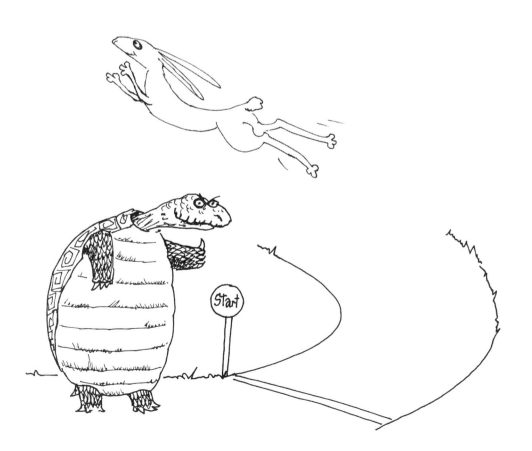

Draw the old movie villain.

Have you ever wished that wigs were still in fashion?

Design a really comfy chair.

No ... can you bring on the next one?

What is hanging round her neck?

What are the jesters juggling?

Finish the plumbing.

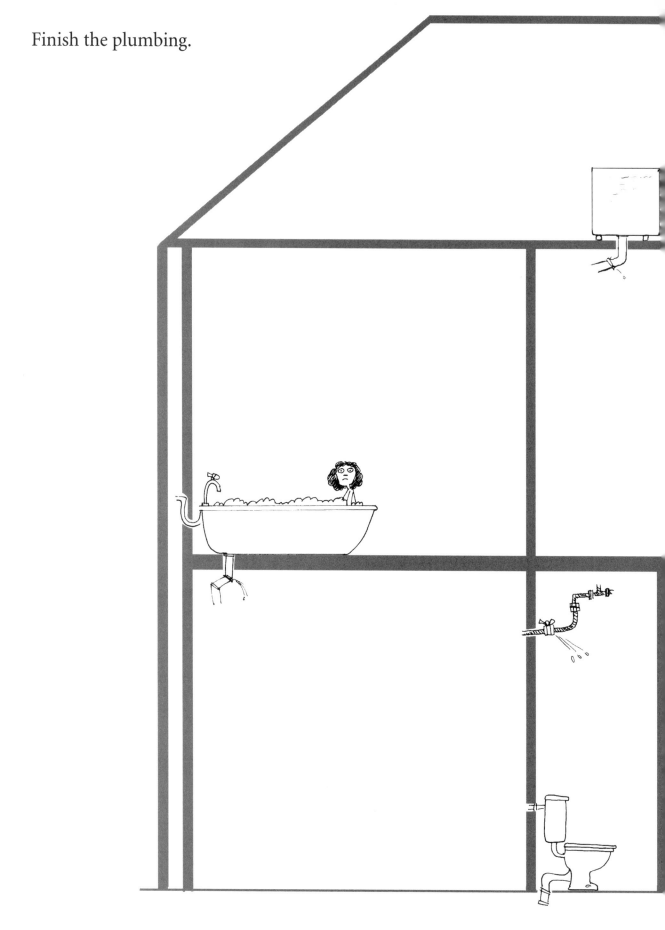

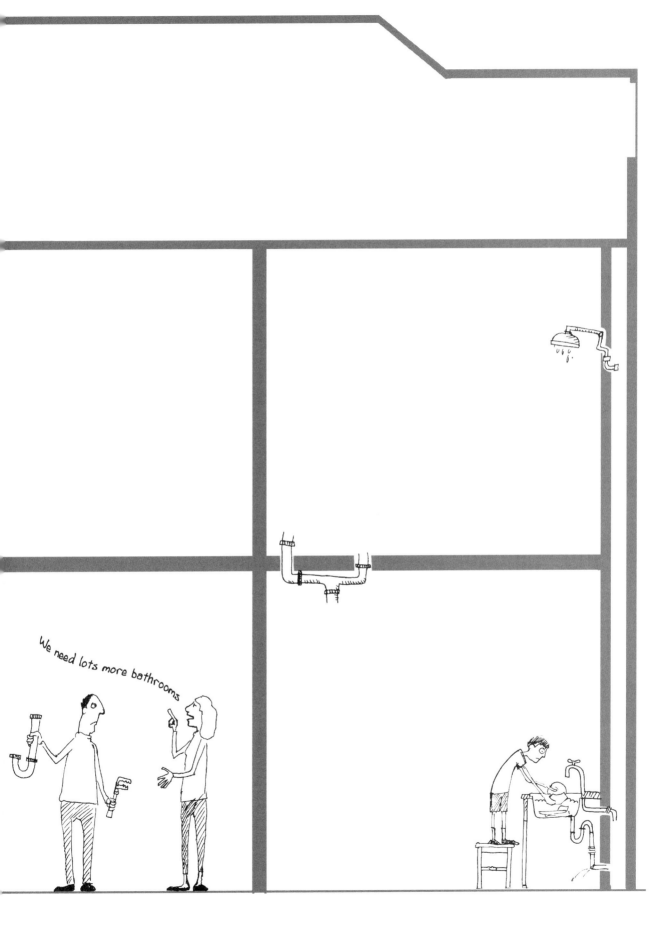

Senior pastimes 6 – Knitting

Get your own back on your children. Knit them hideous jumpers.

Design a dog walker.

Health and safety gone mad! Old-fashioned playgrounds never did us any harm.

Create a really good youth trap.

Grandma is getting stressed.
How many grandchildren is she looking after?